BP PORTRAIT AWARD 2014

National Portrait Gallery

Published in Great Britain by
National Portrait Gallery Publications
National Portrait Gallery
St Martin's Place, London WC2H 0HE

Published to accompany the BP Portrait
Award 2014, held at the National Portrait
Gallery, London, from 26 June to 21
September 2014, Sunderland Museum
and Winter Gardens from 4 October to
16 November 2014 and Scottish National
Portrait Gallery from 28 November 2014
to 12 April 2015.

For a complete catalogue of current
publications please write to the address
above, or visit our website at
www.npg.org.uk/publications

ISBN 978 1 85514 486 6

A catalogue record for this book is
available from the British Library.

10 9 8 7 6 5 4 3 2 1

Managing Editor: Christopher Tinker
Project Editor: Andrew Roff
Design: Richard Ardagh Studio
Production: Ruth Müller-Wirth
Photography: Prudence Cuming
Printed and bound in Italy
Cover: *Eddy in the Morning*
by Geoffrey Beasley

Supported by BP

25 Celebrating
twenty-five years of
support by BP

FSC
www.fsc.org
MIX
Paper from
responsible sources
FSC® C016114

CONTENTS

DIRECTOR'S FOREWORD

What makes a great contemporary painted portrait is the central question for each year's BP Portrait Award. One might consider the principles of good composition, pose and figure construction, potential likeness and the rendering of head and face, technical skill – whether more realist or expressionist in style – and the use of narrative or symbolic elements. However, it is the process of viewing the portraits entered (more than 2,000 this year) that really offers answers to this question. All the judges have immediate but differing responses to the images – sometimes expressed as if meeting a real person who might have walked into the judging room; sometimes expressed as praise for the extraordinary skills displayed by painters in particular works. Once the longlist has been reduced down to the works in closest contention, the strength of a specific portrait emerges from face-to-face encounter. Gradually there is agreement about the best works to be selected for the exhibition and, after considerable debate, a consensus about the prizewinners.

The competition is based on anonymous judging: the judges have no knowledge of the artist being considered. The BP Award puts considerable focus on the relationship between artist and sitter, and the sense of that encounter is at the heart of an excellent portrait. This year's prizewinning portraits are painted in a range of styles. And the overall winner, Thomas Ganter, has produced a painting of great compassion. We meet his subject, Karel, as if in the street in Germany but now transformed, with dignity, into painted form.

This is the twenty-fifth year of sponsorship by BP of the competition, which now encompasses the exhibition, the Travel Award, the commission and, more recently, the Next Generation workshops. It is a really exceptional record of support that has made a huge difference to so many artists over this quarter century and supporting an exhibition that has been seen by more than five million people over the years. The National Portrait Gallery is very grateful to BP and in particular to Bob Dudley, Chief Executive, as well as to Ian Adam, Peter Mather, Des Violaris and other colleagues at BP.

Sandy Nairne
Director, National Portrait Gallery

SPONSOR'S FOREWORD

It has been said that portraits reveal as much about the artist as the sitter. From BP's point of view, I like to think that the institutions we are able to support also reveal something about who we are as a company. In sponsorship, as in our business generally, our aim is the pursuit of excellence in meeting a fundamental human need, be that the need for energy or for artistic expression.

The work exhibited during our twenty-five years sponsoring the BP Portrait Award has been of a very high standard, with 2014 being no exception. And the increasing number of artists submitting entries each year – a record 2,377 entries this time – as well as the numbers visiting the exhibition, suggest we are supporting something that gets at the essence of our society. On behalf of BP I would like to congratulate the winners and thank every artist who submitted their work. I would also like to thank Sandy Nairne, Pim Baxter

and the team at the National Portrait Gallery for their professionalism and dedication.

Each year we seek to find new ways to encourage new talent with innovations such as the BP Travel Award and the BP Portrait Award: Next Generation. The former helps artists to explore otherwise inaccessible corners of the world in search of insight and inspiration, while the latter has so far enabled over a thousand fourteen- to nineteen-year-olds across the UK to learn directly from seventy BP Portrait Award-winning artists.

Connections such as these, and competitions like the BP Portrait Award, are essential for developing great art and great artists. BP is proud to play a part through its long-standing partnership with the National Portrait Gallery.

Bob Dudley
Group Chief Executive, BP

Licence to Stare

Julia Donaldson
Novelist

'Don't stare – it's rude.' Every child must have been told that, and most of us by adulthood have curbed our natural instinct to gaze curiously and openly at other people. Perhaps that helps to explain the allure of portraits: they give us licence to stare.

A face is of course much more than a set of features; it is, or can be, a fascinating character map. On a recent wander round the National Portrait Gallery I came face-to-face with Henry VII's air of calculating shrewdness, his granddaughter Queen Elizabeth I's haughtiness and Oliver Cromwell's self-righteous determination.

Occasionally, though, a portrait can be disconcerting, and you almost have to avert your gaze. It's as if the licence to stare applies to the sitter as well as the viewer. Lady Ottoline Morrell looks down at you from her frame with a witty, aristocratic sneer, making you feel slightly uncomfortable, even judged, and I always feel that the emaciated Cardinal Newman's eyes are following me around the room, perhaps sensing my past misdeeds like a confessor.

In other portraits you have the feeling that it's not you the sitter is interested in, but the painter: twenty-year-old Emma Hamilton, her head modestly swathed in white muslin and tilted demurely à la Princess Diana, is surely flirting with George Romney – or maybe it's just that he was in love with her.

Then there are the sitters who appear unaware of either painter or viewer, being too intent on the palette in their hand, the piano they are playing or the book they are reading. Even though there is no eye contact, it's clear enough what these people care about. More intriguing are those who make you wonder: an example is the chalk drawing by Dante Gabriel Rossetti of his sister Christina and their mother. Pictured in profile, the two women gaze seriously and pensively in the same direction. They are deep in thought – but about what, you long to know.

Often our natural curiosity about people extends to their taste. Their clothes interest us, and so do their surroundings. I'm sure I'm not alone in my fascination with other people's rooms. I love walking along a residential street, especially as dusk falls and lights are switched on, and taking a sneaky glimpse into the basement or ground-floor windows. But again, it doesn't do to stare or at any rate to be caught doing so. So I for one really like those portraits in which the sitter is in their own home or work place, such as the one of the Victorian playwright and novelist Charles Reade. The painting shows Reade writing busily in his sitting room with its red curtains and rugs and

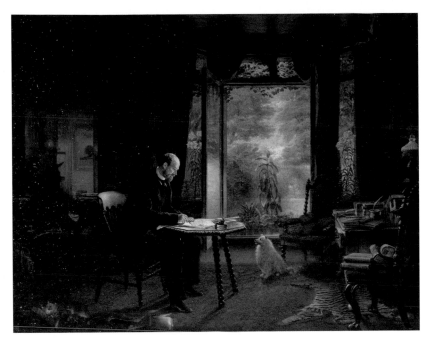

Charles Reade (1814–84) attributed to Charles Mercier, c.1870 (NPG 2281)
Oil on canvas, 1099 x 1403mm

dark oak furniture, while a cat sleeps and a white dog waits patiently for his master to reach a good stopping place and take him out through the open French windows into the lush greenery and the possibly brewing storm.

More stilted but nevertheless compelling (since people have always been nosy about royalty) is the painting entitled *Conversation Piece at the Royal Lodge, Windsor* (overleaf), in which King George VI is depicted having tea with his wife and daughters. Instead of the usual formal royal group portrait, we see Queen Elizabeth (later the Queen Mother) pouring the tea while Princess Margaret leans forward with her arms on the table and Princess Elizabeth

(the present Queen), about to take a seat, looks quizzically at her father, who seems to be considering what to say next. I like the mixture of formality and relaxation: the room, with its lace tablecloth, lilies and gold-framed pictures is quite prim and proper, but behind the off-duty king's chair a dozing corgi softens the scene, conveying the message that this is a real family with pets. (I have read that the artist, James Gunn, drew this dog as a movable cut-out and repositioned him several times.)

A room can do more than give us a glimpse into the sitter's everyday surroundings; it can help to create a mood. I find one of the most touching interiors in the Collection is that of John Keats's house in

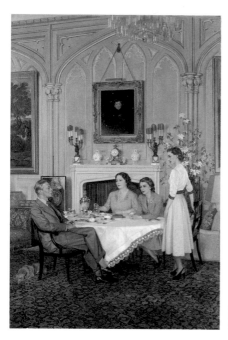

Conversation piece at the Royal Lodge, Windsor
by Sir James Gunn, 1950 (NPG 3778)
Oil on canvas, 1511 x 1003mm

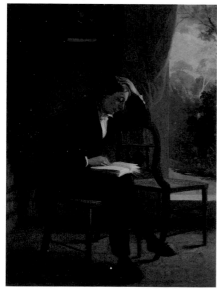

John Keats (1795–1821)
by Joseph Severn, 1821–3, dated 1821 (NPG 58)
Oil on canvas, 565 x 419mm

Hampstead, north London. This is a retrospective portrait, painted by Keats's great friend Joseph Severn after the poet had died (in Severn's arms). Severn wrote that 'After the death of Keats the impression was so painful on my mind, that I made an effort to call up the last pleasant remembrance . . . This was at the time he first fell ill & had written the *Ode to the Nightingale* [1819] on the morning of my visit to Hampstead. I found him sitting with the two chairs as I have painted him & was struck with the first real symptoms of sadness in Keats so finely expressed in that poem.' Even without the benefit of Severn's commentary, the viewer is struck with a sense of melancholy beauty: the shadows of the two chairs and of the soulful-looking Keats contrasting with the brightness of the open book on his lap and the inviting beauty of the garden outside the open door.

A more recent painting in which surroundings illuminate character is that of the pioneering chemist Dorothy Hodgkin by Maggie Hambling (page 13). In this 1985 portrait, the snow-reflected light from a casement window falls upon a mass of papers, books and files, while in the foreground is a complicated model of the structure of insulin, consisting of dozens of interlinked beads and wires. All of this heightens our awareness of the sitter's complex thought processes, as her arthritic hands (each one painted double, to indicate the speed of her mind and the intensity of her passion for scientific discovery) race across the paper on which she is sketching a diagram.

Another, much starker, favourite of mine is James Lloyd's 2012 portrait of Maggie Smith (page 13). No background objects or ornaments here – the electric cable and the pipework in the bare room are exposed and there is a crack in the wall, while Dame Maggie herself wears a plain floppy grey jacket and black trousers. There is sadness as well as warmth in her expression, and the message that comes over is one of honesty: there is no attempt at embellishment or cover-up – this is who I am. Nothing could be in stronger contrast to the flattering 'Ditchley' portrait of Queen Elizabeth I with her sumptuous embroidered dress, lace ruff, strings of pearls and improbably smooth hands, standing omnipotently on a globe of the world.

There are, in fact, relatively few detailed pictures of interiors in the National Portrait Gallery. More commonly the backgrounds of these paintings of eminent people are plain and sombre, or else symbolic. Charles I stands beside his crown and sceptre against a backdrop of royal red velvet. Christopher Wren holds a compass and rests his arm on a table where the plan of St Paul's Cathedral is laid out. Steven Hawking is depicted against a blackboard covered in an impressive array of symbols and equations. Then there are those paintings combining portrait and landscape: I love the one of Beatrix Potter sporting an umbrella and a green felt hat with a Lakeland scene behind her, complete with farm-workers and rams. (She bought a farm with the proceeds of her children's books and became a prizewinning sheep-breeder.)

In the annual BP Portrait Award exhibition, the percentage of backgrounds showing detailed rooms is usually much higher than in the main Gallery. I assume this is because the paintings entered for the award tend to be 'portraits of affection', often of family members, friends and neighbours rather than of renowned achievers. In 2012 I had the privilege of wandering around the exhibition with the artist Peter Monkman, who had won first prize three years previously for his portrait of his daughter *Changeling 2*.

Peter had been commissioned by the Gallery to paint me, and this was the first time we had met. He gave me a lot of insight into the art of portraiture, and I think he also picked up on my weakness for pictures of rooms. At any rate, when he later came to visit me in Glasgow and do some preliminary sketches, he was very taken with my 'props room'. This is the smallest room in my house, with floor-to-ceiling shelves on three of its walls. The shelves are crammed with the props I use when acting out my stories at book festivals and in theatres. This performance aspect of my work means a lot to me – probably as much as the writing itself – but I had rarely been able to interest any visiting journalists in the props room or get photographers to snap me there. They would usually take a cursory glance and then say, 'I see – and can you tell me, what gave you the idea for *The Gruffalo*?' To my delight, Peter clearly thought the shelves would make a suitable background, at once illuminating and mysterious.

I didn't want it to be too obvious what the different objects behind me were. It would have seemed a bit corny and condescending to show a children's author with a mermaid, a witch's hat, a monkey puppet and so on. To my relief Peter agreed and was happy for me to turn some of the things round, presenting just a glimpse of the Gruffalo's purple prickles, the mermaid's blue shimmering tail and the tresses of the ghost's disembodied head; the idea was that these should come across as glimpses into my imagination, as well as providing interesting colours and textures. I think it was Peter's idea for me to be holding a notebook and pencil, as if I might be writing a story about the viewer.

I'd never had my portrait painted, but since I absolutely hate lengthy photoshoots I wasn't entirely looking forward to the experience. I imagined I would not be allowed to twitch a muscle, and I also had a terror of feeling bored, since sitting still and unoccupied is not something I normally do. If I haven't got a book, a crossword or a game of Sudoku I tend to panic.

In fact the whole procedure was surprisingly enjoyable. On that visit to my house Peter did some quick sketches and took some (mercifully even quicker) photos as a way of becoming acquainted with my features, and perhaps, too, as a way of getting to know me, since we talked quite a lot. When I next saw him, several months later in his studio, he had already painted a lot of the portrait, using the sketches

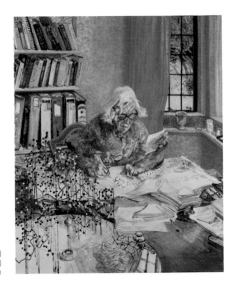

Dorothy Hodgkin (1910–94)
by Maggi Hambling, 1985 (NPG 5797)
Oil on canvas, 932 x 760mm

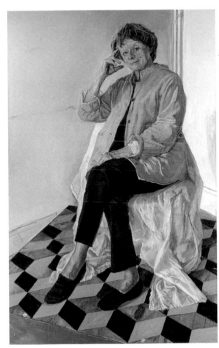

Dame Margaret ('Maggie') Smith (b.1934)
by James Lloyd, 2012 (NPG 6955)
Oil on canvas, 1902 x 1202mm

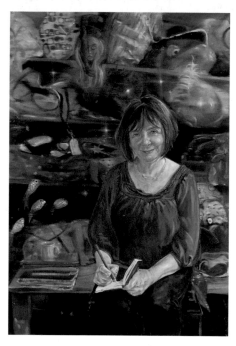

Julia Donaldson (b.1948) by Peter Monkman, 2013 (NPG 6960)
Oil on canvas, 1550 x 1070mm

and photos as a guide. He then needed me to do four two-hour sittings over two days, so he could change some things, add some details and paint my hands. This time I had to keep even more still, but I found it was quite soothing to be able to fix my gaze on a picture on his wall and contemplate it at length, while listening to hours of Radio 4.

I had imagined that I would feel uncomfortable looking at the finished portrait, perhaps because it's life-size and I am someone who studiously avoids mirrors. In fact this is not the case. I feel detached rather than self-conscious, though it's quite different from looking at other sitters

because the experience lacks that ingredient of curiosity.

So now you have licence to stare at me. But I warn you that I am one of the ones who stare back, as my pencil hovers above my notebook: I may not feel curious about myself, but I am curious about you.

Julia Donaldson is one of the UK's most successful authors and her prizewinning books for children include *The Gruffalo* and *Room on the Broom*. In 2011 she was appointed Children's Laureate and received an MBE in the Queen's Birthday Honours for her services to literature.

14

BP PORTRAIT AWARD 2014

The Portrait Award, in its thirty-fifth year at the National Portrait Gallery and its twenty-fifth year of sponsorship by BP, is an annual event aimed at encouraging young artists to focus on and develop the theme of portraiture in their work. The competition is open to everyone aged eighteen and over, in recognition of the outstanding and innovative work currently being produced by artists of all ages working in portraiture.

THE JUDGES

Chair: Sandy Nairne,
Director,
National Portrait Gallery

Sarah Howgate,
Contemporary Curator,
National Portrait Gallery

Dr Alexander Sturgis,
Director of the Holburne Museum,
Bath

Joanna Trollope,
Writer

Des Violaris,
Director, UK Arts & Culture, BP

Jonathan Yeo,
Artist

THE PRIZES
The BP Portrait Awards are:

First Prize
£30,000, plus at the Gallery's discretion a commission worth £5,000.
Thomas Ganter

Second Prize
£10,000
Richard Twose

Third Prize
£8,000
David Jon Kassan

BP Young Artist Award
£7,000
Ignacio Estudillo Pérez

PRIZEWINNING
PORTRAITS

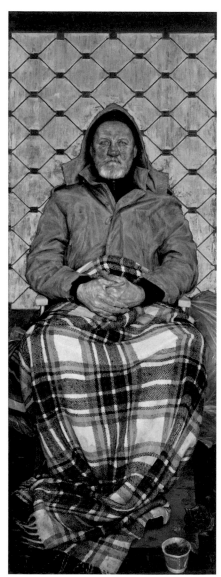

A chance sighting outside Frankfurt's Städel Museum provided Thomas Ganter with the inspiration for his winning entry in the 2014 BP Portrait Award. Having spent a rainy afternoon viewing the Städel's renowned collection of Old Masters, the German artist was struck by the similarities between many of the museum's paintings and a homeless man he noticed on a nearby street.

'I was stunned by how the man's clothes, pose and other details resembled what I had seen in various paintings in the museum,' he recalls. 'However, this time I was looking at a homeless person wrapped in a blanket and not at the painting of a noble in an elaborate garment.'

Ganter began to develop the basic idea for *Man with a Plaid Blanket*, starting with conceptual sketches and colour studies, and guided by the work of Diego Velázquez, Hans Holbein and Jan van Eyck. 'The execution and composition of their paintings was a great inspiration,' he notes. 'For most of my work, I try to translate my thoughts, emotions or message into a visual language. Once the sketches reflect my idea, I start the painting.'

Ganter wanted the portrait to contain a 'political statement about the contrast between wealth and poverty', and asked Karel Strnad, a local homeless man, to sit for the painting. 'Karel is a well-known figure in the neighbourhood, and earns money by cleaning car windscreens. His charisma and physiognomy have always impressed me. By painting him in a way that only nobles or saints used to be portrayed, I tried to

emphasise that everyone deserves respect, attention and care.'

After preparing the canvas, Ganter made a rough underpainting with dry acrylics, then worked with various semi-transparent layers of liquid oil colours in *alla prima* technique, using opaque oils for the highlights and the deepest shadows. The head and hands were painted during five sittings before Ganter used a life-sized doll to complete the clothes and blanket. 'The portrait has a deliberate combination of details and haziness,' he explains. 'The details help me to communicate with the viewer, while the haziness leaves people room for their own thoughts and interpretation.'

The forty-year-old artist, who was born in Limburg, is largely self-taught and originally worked as a lithographer before studying illustration at the University of Applied Sciences in Wiesbaden. In 2001, he co-founded Kawom, an animation and illustration agency where he continues to work.

'Being an illustrator helps my art by the daily exercise of drawing, painting and thinking in concepts,' he says. 'There's a big difference, however. As an illustrator, I have to accommodate clients' wishes, while as an artist I can follow my passion. Most of my canvases try to capture the beauty of visual appearances while including a message, whether it's the impact of globalisation or social inequality. The picture we have of our world is often distorted and I try to revise this through my work, ideally condensed in a portrait.'

Interview by Richard McClure

Jean Woods
Richard Twose

Oil on board,
900 x 600mm

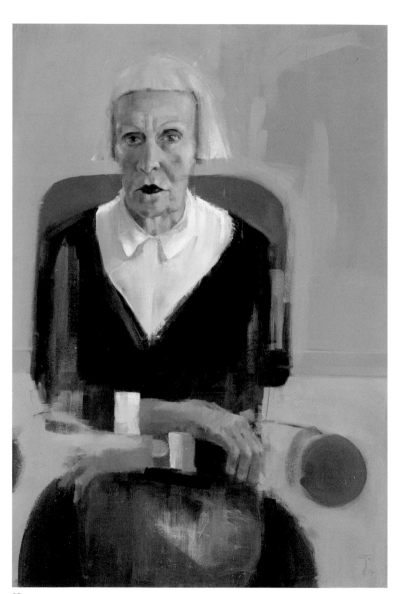

Richard Twose began his career as a professional artist in 2010 following the collapse of his jewellery-making company. Having designed burnished gold, mythology-inspired pieces for the likes of Paul Smith, Harvey Nichols and Barneys New York, his 'inability to grasp the basics of cash-flow and balance sheets' during the recession saw the business go bust, leaving him and his young family facing a precarious future.

Leaving central London for a village outside Bath, Twose began painting from a small studio at his home while also teaching art and history of art at a sixth form college in Bristol. 'I learned to paint in order to teach my students and grew to love it,' he says. 'I started with acrylics but never liked them. Then I fell in love with oils, the richness of colour and the way you can create a world fully contained and very intense, but it took a long time before I felt ready to show any work to galleries.'

Twose's interest in fine art had begun during his teenage years in Torquay. 'My family went through some very difficult times in the late 1970s and I left home to become a vegan, hunt saboteur and punk, living on Dartmoor and working on farms,' he recalls. 'But all the time I kept drawing; hundreds of sketchbooks, like an ongoing visual diary. At the time, the concept of being an artist didn't enter my head – it was something from the past or something other people did.'

Now aged fifty, Twose is represented by Bath Contemporary Gallery, View Art Gallery in Bristol and The Art Movement in London. As well as portraiture, his wide-ranging body of work includes urban landscapes of motorways and dual carriageways, and interiors featuring blurred human figures that explore ideas of impermanence and change.

His second-prize entry in the BP Portrait Award depicts Joan Woods, a fashion model he met while she was working in a shop in Bath. Drawn to her 'contemporary, edgy look and the depth of character in her face', he invited Woods to his studio for a series of sittings over two months.

Twose painted the image onto board rather than canvas so that he could sandpaper and 'attack' the surface, revealing previously painted layers underneath. At first, he asked Woods to focus on a point in the room, but found that the portrait 'struggled to come to life' until he repainted her eyes to make them directly regard the viewer.

'Jean was very professional as a sitter, not just because of her experience as a fashion model but more due to a quality of stillness she seems to possess naturally,' he says. 'Sometimes as she was talking, especially about her much-missed late husband, she reminded me of Rembrandt's *Portrait of Margaretha de Geer*. Jean has a similar intensity and honesty in her gaze. I wanted to capture that sense of someone who has learnt to be almost fearless, looking forward to life still, but with a great richness of experience behind her.'

Interview by Richard McClure

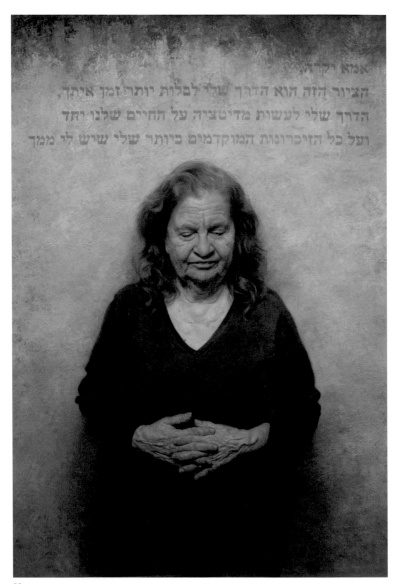

In recent years, Brooklyn-based artist David Jon Kassan has increasingly focused on painting family members and close friends in order to 'learn more about them and the connections between us'. His third-prize entry in the BP Portrait Award, *Letter to My Mom*, is a study of his retired mother Roberta, who now lives in Florida. 'My work is very personal and heartfelt, like a visual journal, so my loved ones make up a large part of what and why I paint,' explains Kassan. 'I only see my parents once a year, so the paintings are my way of trying to bring them closer to me.'

Having been painted by her son before, Roberta was unwilling to sit again, but relented when she was offered a portrait of her grandson as recompense. This time, the artist incorporated a message to his mother in Hebrew, expressing his desire for the painting to act as a meditation on their shared experiences. Taking a year to complete the portrait, Kassan used binoculars throughout the sittings in order to view areas of light and dark more accurately, and worked in oils on aluminium rather than canvas. 'I want my paintings to mimic life, not a painting,' he remarks. 'For me, a canvas weave, however fine, always says "painting".'

Although he seeks 'to make as lifelike a painting as possible, so that the sitter comes to life', Kassan refuses to be labelled a photorealist. 'I'm not trying to make my work look like photographs, though I do strive to make the technique disappear, so you are thinking more about the model's expression and emotion rather than the movement of a brushstroke. I want a connection between the subject and the viewer; I don't like to put myself in the middle of that interaction. I'm in the paintings enough with the choices that I make concerning the pose, composition or background.'

Born in Little Rock, Arkansas, in 1977, Kassan graduated with a bachelor of fine arts degree from Syracuse University in 1999 and worked as a web designer in Manhattan until losing his job in 2001 when his employers lost funding in the aftermath of the terrorist attack on the World Trade Center. 'I was extremely shaken by 9/11. Smelling the burning site for days after, I realised that life is short and decided to be steadfast in pursuing my painting full time. I was going to sink or swim.'

After a period of near-poverty, Kassan is now represented by Gallery Henoch in New York, exhibits throughout the US, and has set up his own foundation to provide financial assistance to young artists and musicians. He is also regarded as a pioneer in the use of digital technology, attracting thousands of views on YouTube for his iPad portrait workshops using the Brushes app on the touchscreen device.

'I don't really consider the studies I've done on the iPad as art; I mainly use it as a sketch tool to augment my real paintings,' he says. 'But if Leonardo was around today he'd be using an iPad. He'd be a total tech geek like me.'

Interview by Richard McClure

Mamá (Juana Pérez)
Ignacio Estudillo Pérez

Oil on canvas,
1650 x 1420mm

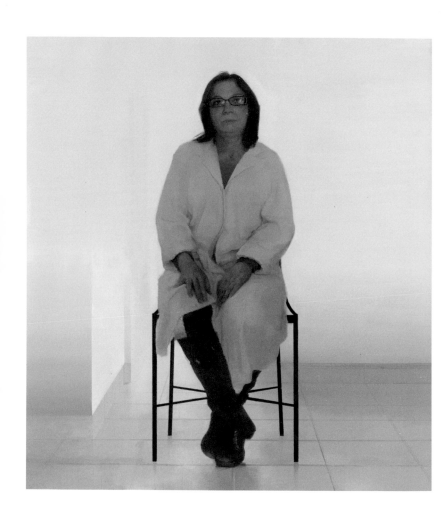

A close-knit family of larger-than-life characters has provided a valuable source of subject matter for Ignacio Estudillo Pérez. In 2012, the Spanish artist received second prize in the BP Portrait Award for a study of his grandfather. This year, he is the winner of the BP Young Artist Award for a portrait of his mother, Juana, a hospital worker in the family's hometown of Jerez de la Frontera.

'A passion for art runs in the family and has been handed down to me in a very profound way,' says Estudillo. 'I paint everything and anything that catches my interest, but my family has always been my biggest inspiration. I have a lot of respect for my mother and I hope her portrait moves people.'

Painting in oils, Estudillo took two and a half years to complete the work, a lengthy process that required numerous sittings in the artist's living room. After abandoning an earlier effort that he felt failed to capture his mother's spirit, he switched to a 'less forced pose, showing a direct relationship between us' and experimented with several differently coloured backgrounds before choosing a 'disagreeable white, rather than a white of purity'.

Estudillo also wanted the image to convey something of the hardships afflicting his hometown. Once famous for its sherry and flamenco festivals, Jerez de la Frontera has been blighted by widespread job losses and cuts in wages and services due to the eurozone crisis. Unemployment in the city is approaching forty per cent accompanied, by a rise in suicides and repossessions.

'My family is not having an easy time, like many others in Spain, and that can be seen etched in the faces of the people in my neighborhood,' he says. 'My mother works long hours in the local hospital and I wanted to portray the monotony of that life. Doing the same things every day of your life saps your energy and makes you weary. It is a feeling that haunts me.'

'I wanted the portrait to show some of the good and some of the bad in life, but so much depends on the viewer's own interpretation. I see fatigue in this image; another person will see something else.'

Aged twenty-eight, Estudillo now lives in Malaga after studying at the School of Arts and Crafts in Jerez de la Frontera and the Real Academia de Bellas Artes of Seville while also attending art classes with Spanish realist painter Antonio López García. His landscapes and street scenes have been exhibited across Spain and a portrait of his grandmother is in the collection of the Museu Europeu d'Art Modern (MEAM) in Barcelona.

'I have never considered being anything other than an artist, even though it is a tremendous challenge to make a living from the profession,' he says. 'For me, painting is an exercise in freedom and self-expression. I believe that loving something as profoundly as I love painting has made me a better person.'

Interview by Richard McClure

SELECTED
PORTRAITS

Mujer Sentada (Seated Woman)
Jorge Abbad-Jaime
de Aragón

Oil on canvas,
1460 x 1140mm

Princess Julia in Meadham Kirchhoff
Ben Ashton

Oil on linen,
2080 x 1180mm

Markus
Volkan Baga

Oil on panel,
240 x 300mm

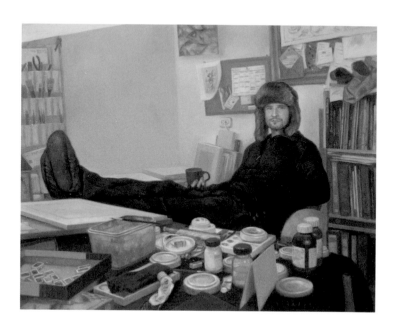

Eddy in the Morning
Geoffrey Beasley

Oil on canvas,
500 x 500mm

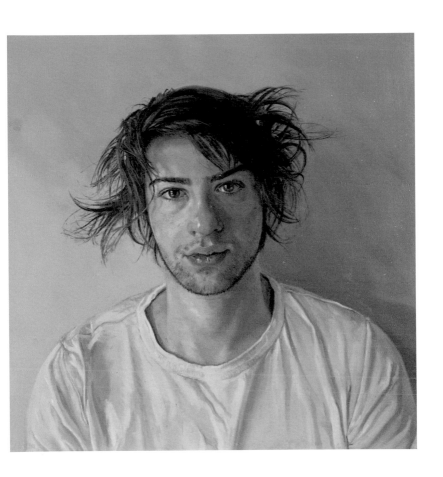

Fergus
Paul Benney

Oil on canvas,
1910 x 1270mm

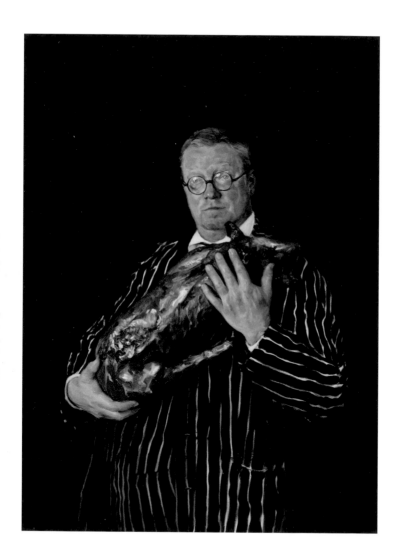

Tony
Jelena Bulajić

Mixed media on linen,
2700 x 2000mm

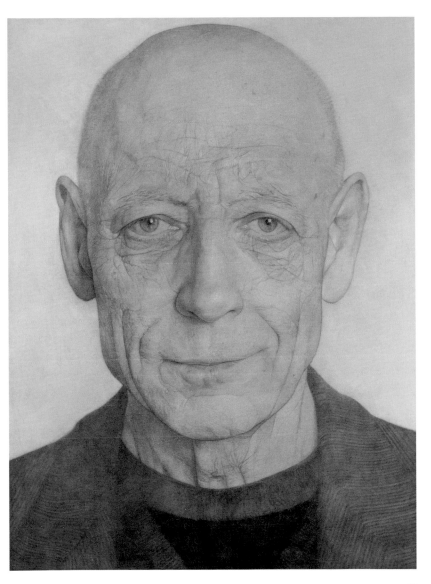

O (Triptych)
Steve Caldwell

Acrylic on wooden panels,
300 x 240mm each

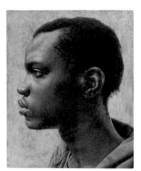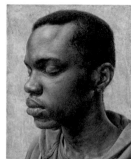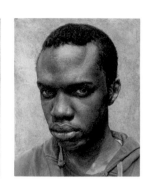

Padre
Maria Carbonell

Oil on board,
1700 x 1000mm

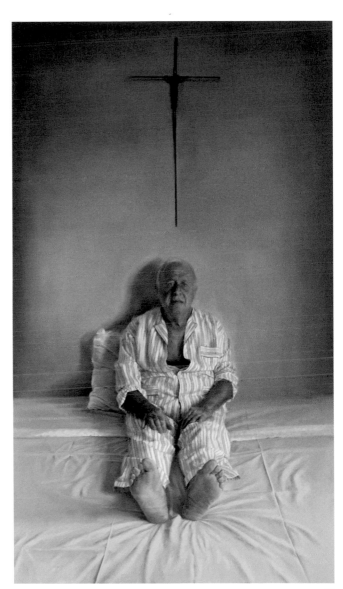

Port de bras
Wayne Clough

Oil on board,
297 x 212mm

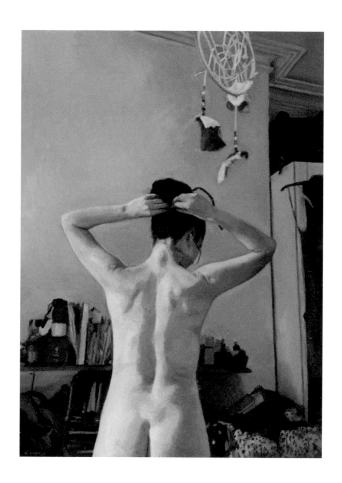

Jordan
Alan Coulson

Oil on wooden panel,
800 x 1000mm

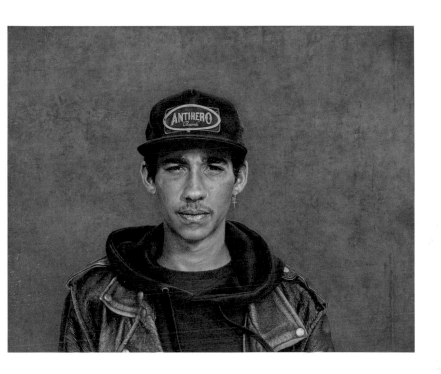

Passers by
Lantian D.

Oil on canvas,
300 x 430mm each

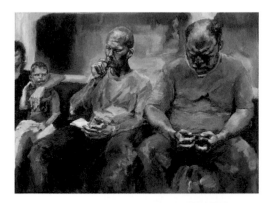

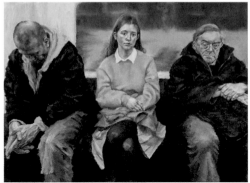

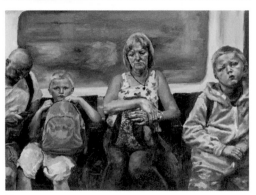

David
Parmen Daushvili

Oil on canvas,
800 x 900mm

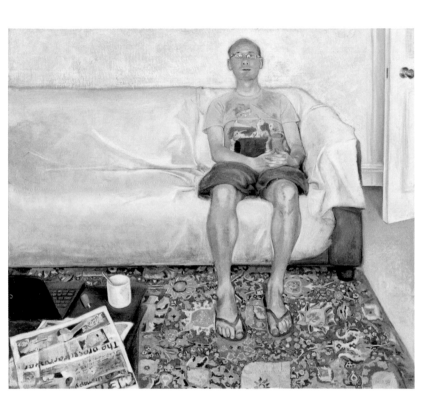

Andrea and Myrtle
Simon Davis

Oil on board,
560 x 350mm

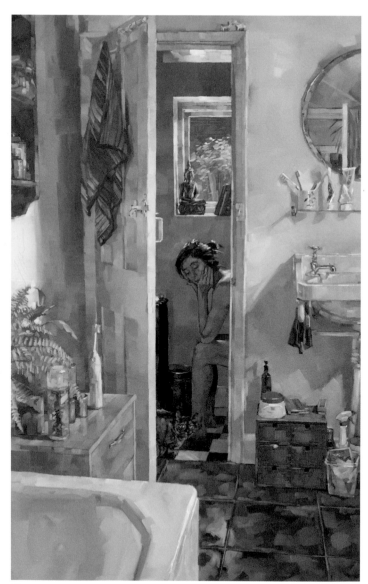

A whole life ahead
Dick de Vries

Oil on board,
250 x 200mm

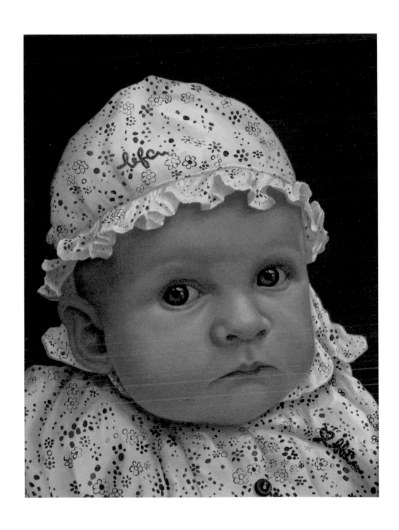

Daughter with Child
Natalia Dik

Oil on canvas,
800 x 650mm

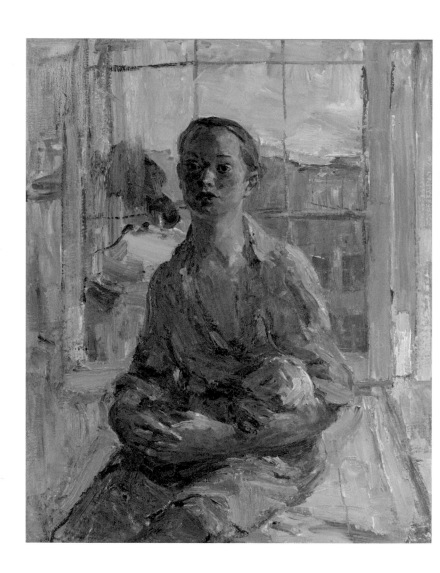

Crazy-eyed Gypsy
Boris Dobre

Oil on board,
330 x 230mm

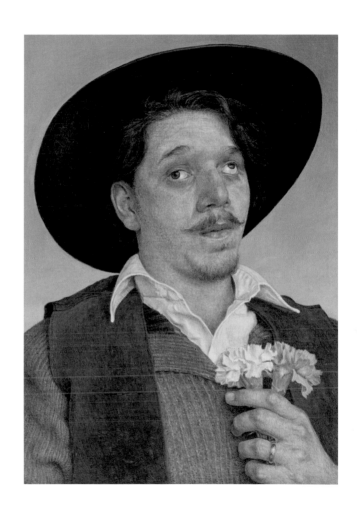

Portrait in Blue and Gold
Clara Drummond

Oil on board,
250 x 200mm

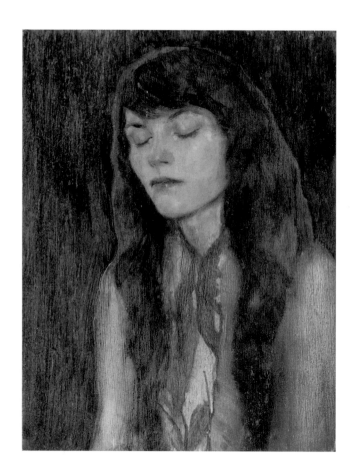

The Twins (Lee and Jason)
Mark Fairnington

Oil on panel,
750 x 300mm each

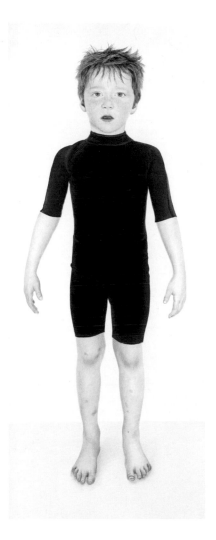
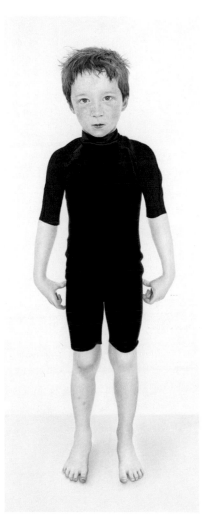

James Martin
Henrietta Graham

Oil on canvas,
2032 x 1010mm

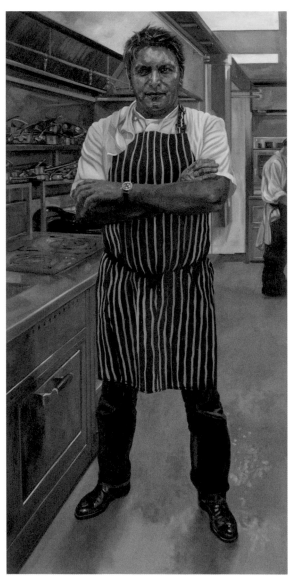

Engels
Patrik Graham

Oil on canvas,
762 x 457mm

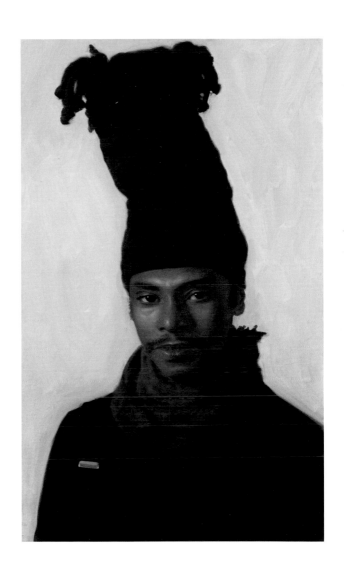

Henrietta and Ollie
Tim Hall

Oil on canvas,
2032 x 1422mm

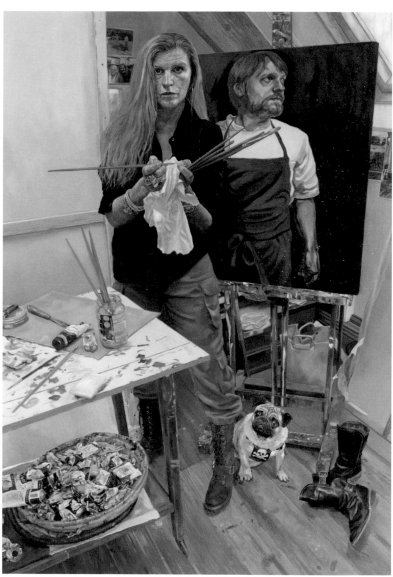

Adam Phillips in memory of Jane Brodie
Eileen Hogan

Oil on wooden panels,
180 x 155mm each

Portrait of Jean Yves, a man looking like
Vincent Van Gogh
Gauthier Hubert

Oil on canvas,
700 x 610mm

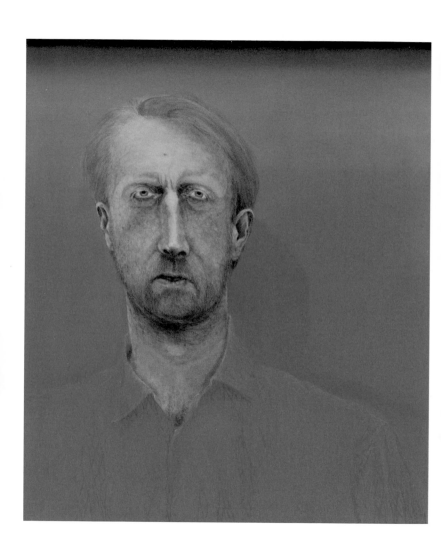

Self-Portrait with Turquoise Tee
Tom Hughes

Oil on board,
600 x 600mm

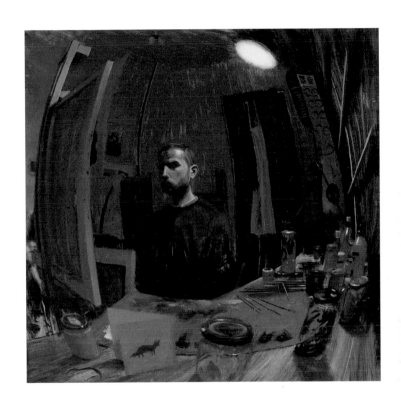

Juan Mosca
Rodrigo Hurtado

Oil on canvas,
1800 x 1200mm

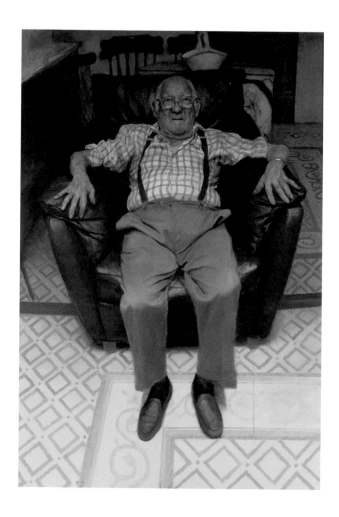

Mother #1
Yunsung Jang

Oil on canvas,
2438 x 2133mm

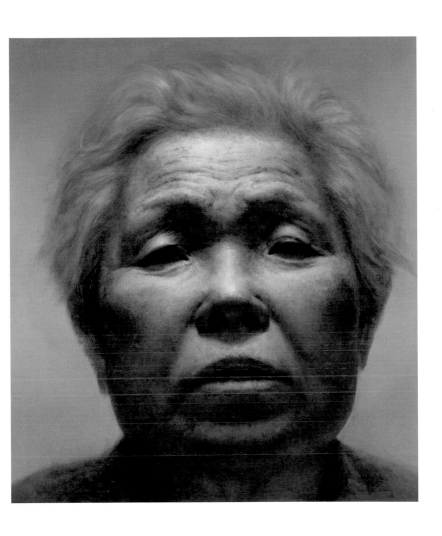

Daylight Bulb
William Klose

Oil on linen,
1100 x 1600mm

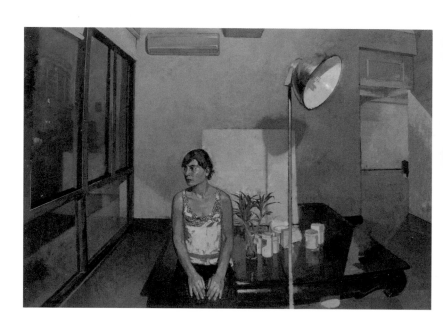

A Young Woman, Becky
Sally Moore

Oil on panel,
810 x 588mm

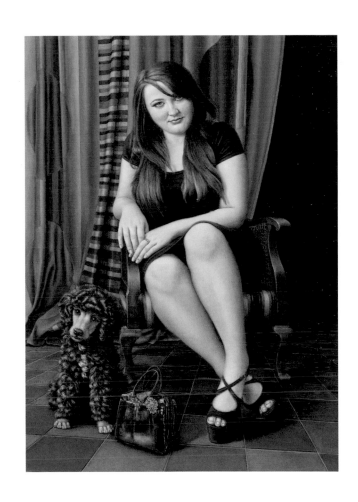

John Byrne and His Guitars
Mark Mulholland

Oil on canvas,
840 x 540mm

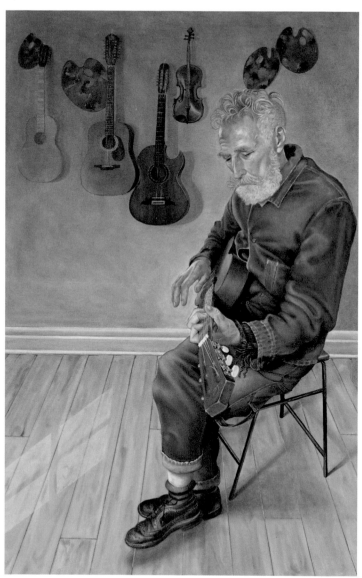

Astrid
Robin L. Muller

Acrylic on board,
431 x 381mm

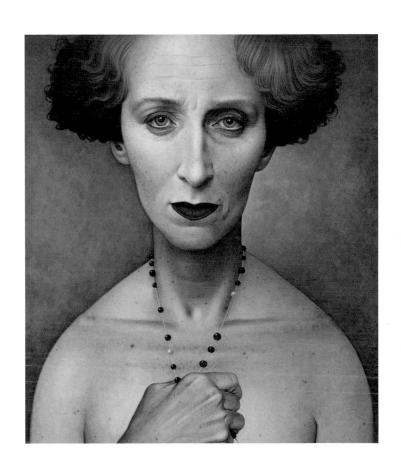

Seek First
John Murphy-Woolford

Oil on gesso board,
200 x 300mm

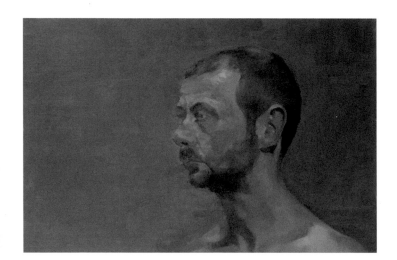

Jeweller
Robert Neil

Oil on canvas,
1000 x 753mm

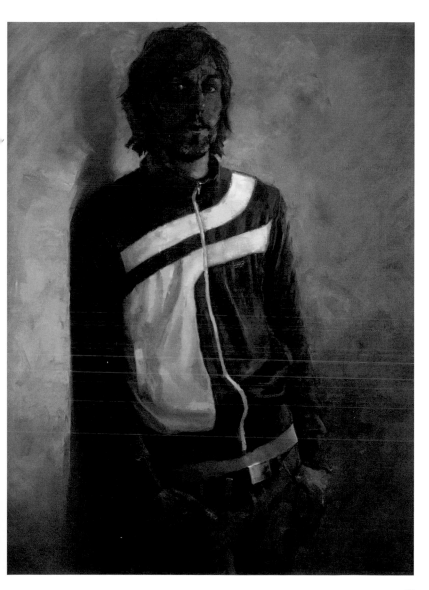

Carolina
Robert O'Brien

Oil on board,
380 x 250mm

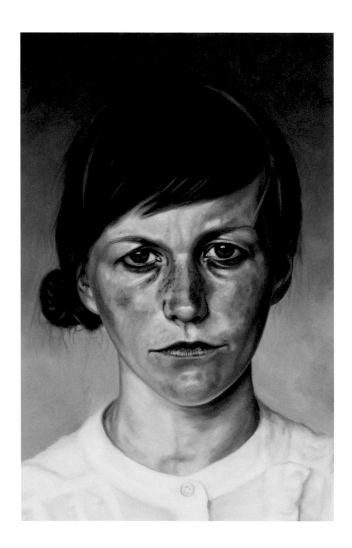

Luciana
Javier Palacios

Oil on board,
1980 x 1980mm

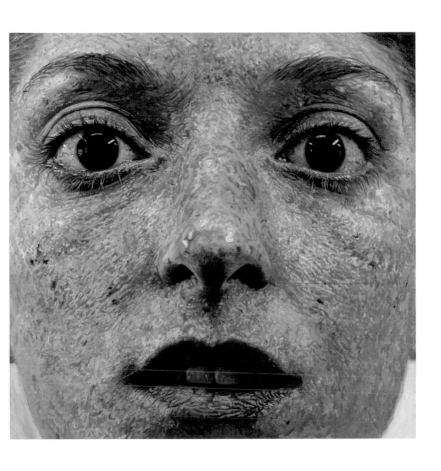

Northern Bather
Gareth Reid

Oil on canvas,
645 x 520mm

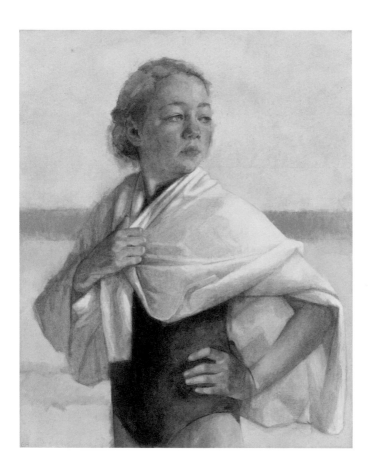

Alan
Philip Renforth

Oil on gesso board,
865 x 815mm

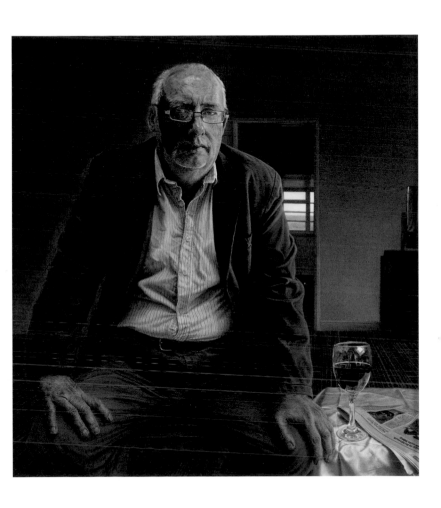

My Boy Adam
Melissa Scott-Miller

Oil on canvas,
1020 x 770mm

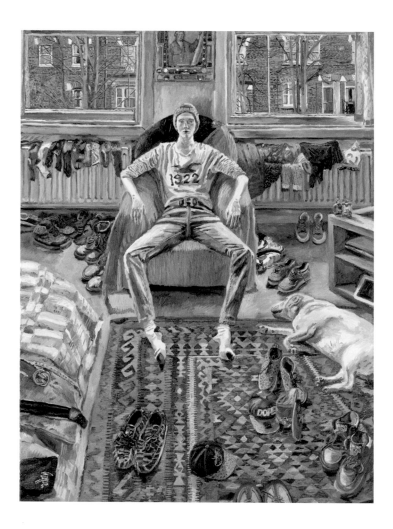

My Parents
Gary Sollars

Oil on canvas,
1500 x 1050mm

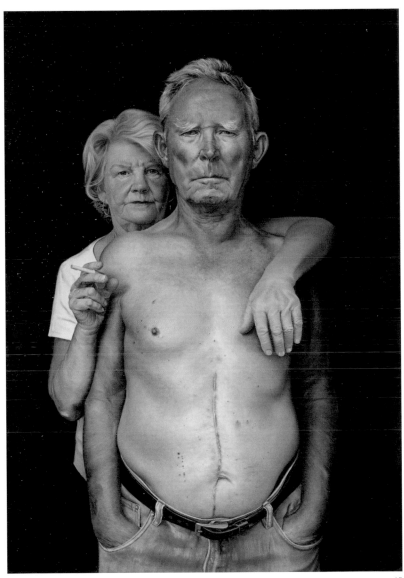

Declan and His Panther Tattoo
Martin Stevenson

Acrylic on canvas,
485 x 370mm

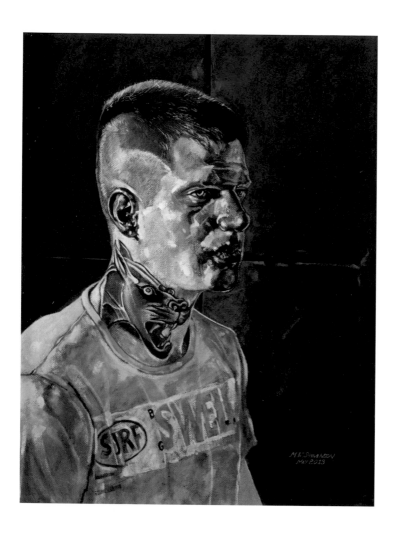

Self-Portrait after the Fire
Lisa Stokes

Oil, graphite and charcoal on canvas,
1525 x 1050mm

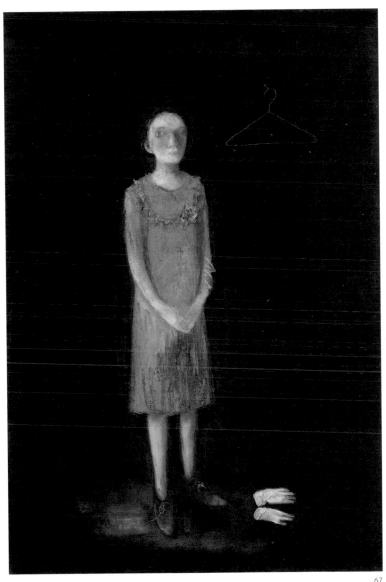

Virginia Sullivan
Benjamin Sullivan

Oil on canvas,
620 x 410mm

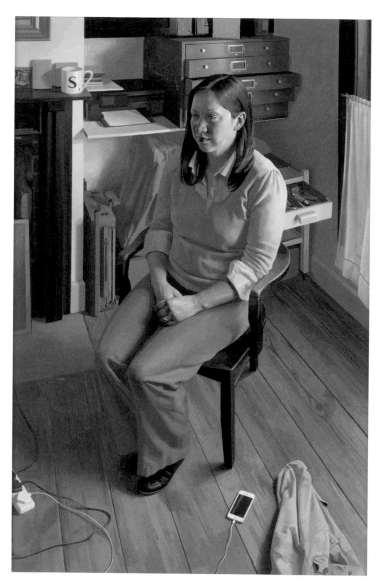

Copycat
Edward Sutcliffe

Oil on canvas,
1495 x 600mm

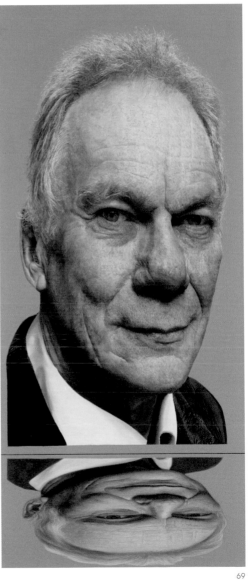

M.F. Husain
Yanko Tihov

Oil on canvas panel,
700 x 500mm

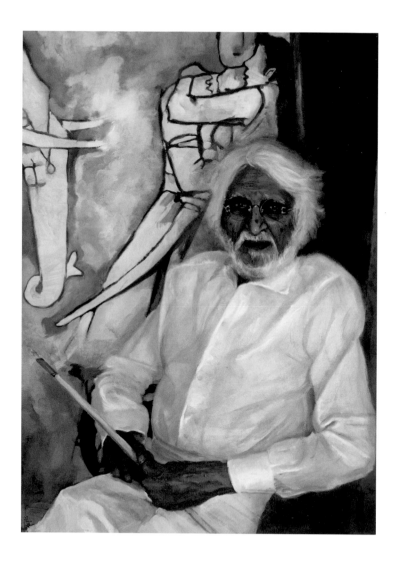

Gina and Cristiano
Isabella Watling

Oil on canvas,
2900 x 995mm

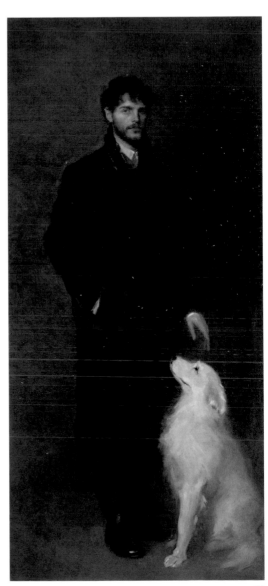

Stefan, 23
Leslie Watts

Egg tempera on wooden panel,
500 x 400mm

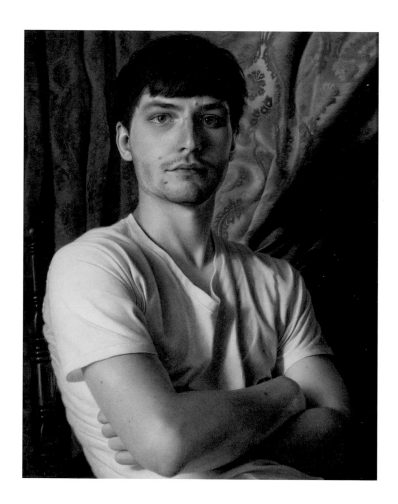

Profile of Emma
Antony Williams

Egg tempera on wooden panel,
489 x 629mm

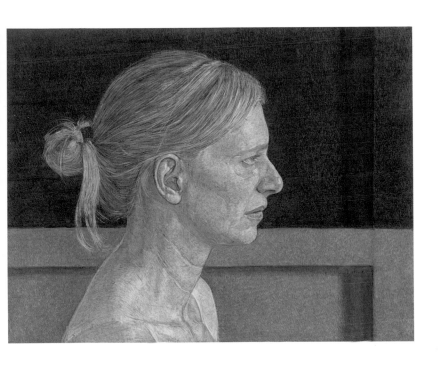

Edward Lucie-Smith
John Williams

Oil on canvas,
655 x 500mm

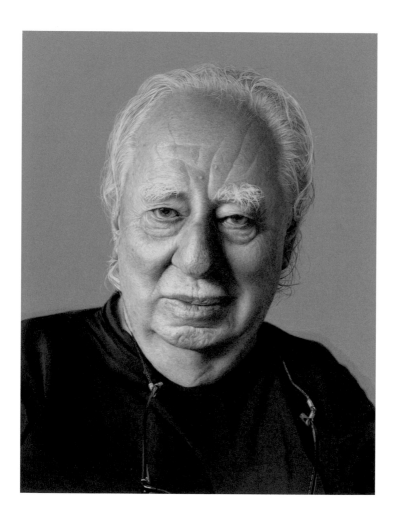

31 Years
Tanya Wischerath

Oil on wooden panel,
914 x 609mm

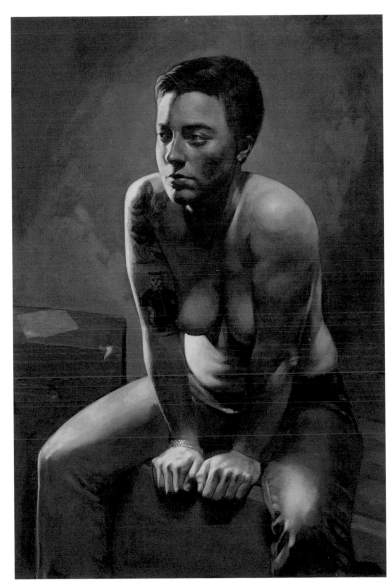

Simon Armitage
Paul Wright

Oil on canvas,
1000 x 900mm

Timothy Spall
Tim Wright

Oil on canvas,
1800 x 900mm

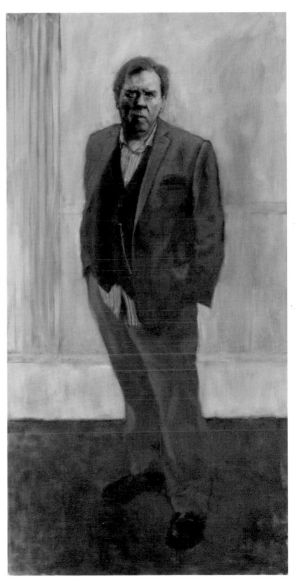

Girl in Red
Anna Wypych

Oil on canvas,
500 x 400mm

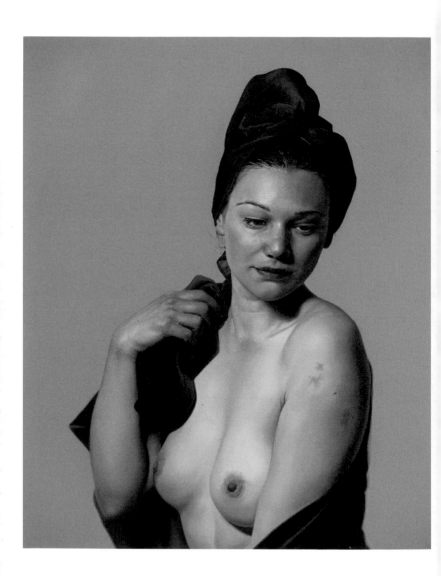

BP TRAVEL AWARD 2013

Each year exhibitors are invited to submit a proposal for the BP Travel Award. The aim of this award is to give an artist the opportunity to experience working in a different environment, in Britain or abroad, on a project related to portraiture. The artist's work is then shown as part of the following year's BP Portrait Award exhibition and tour.

THE JUDGES

Sarah Howgate,
Contemporary Curator,
National Portrait Gallery

Liz Rideal,
Art Resource Developer,
National Portrait Gallery

Des Violaris,
Director, UK Arts & Culture, BP

Sophie Ploeg, who received £6,000 for her proposal to travel to the Netherlands, Belgium and within the UK.

TRAVELLING THROUGH THE FABRIC OF TIME: MODERN RE-IMAGININGS OF LACE IN JACOBEAN PORTRAITURE

Sophie Ploeg

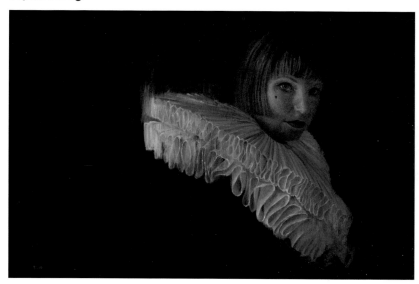

Pleating Time by Sophie Ploeg, 2013
Oil on linen, 400 x 600mm

Since receiving the BP Travel Award in June 2013, Dutch artist Sophie Ploeg has spent the past twelve months immersed in the tradition of lace in seventeenth-century portraiture, drawing on her findings to create ten new oil paintings, some of which will be exhibited at the National Portrait Gallery alongside this year's BP Portrait Award.

Now living in Bristol after moving to the UK from Holland in 2000, the forty-year-old artist developed her interest in fabrics several years ago when she began depicting textiles in her figure paintings and still lives. In the 2013 BP Portrait Award, she

exhibited her oil-on-panel *Self-Portrait with Lace Collar*, a work that expertly juxtaposed the modern and antique. The idea was also central to her winning proposal for the BP Travel Award which centred on how she would interpret the use of fabric and lace in seventeenth-century portraiture in a meaningful and contemporary manner.

'In my proposal, I left the outcome of the project purposefully blank as I did not know where it would take me,' she says. 'All I knew was that I wanted to learn more about seventeenth-century portraits and the fabric, costumes and lace depicted in

them. My work was already infused with history, heritage, femininity, fabric and lace and I thought that studying this period in history would deepen and enrich my work.'

Ploeg's one-year travel commission, *The Lace Trail*, proved to be as much a passage into the past as a journey to any geographic location. The starting point for her research was the work of William Larkin, whose portraits of Jacobean courtiers perfectly illustrate the period's richly decorated fashions, each sitter adorned in elaborate embroidery, ruffs, needlelace or Italian cutwork.

'The first half of the seventeenth century was a fascinating transitional period where portraiture hinged between Tudor and Baroque,' says Ploeg. 'It was also the period when lace first came into high fashion and it features in many portraits. Seeing Larkin's paintings at the Holburne Museum in Bath, I was blown away by the huge display of colour and glamour.'

The trail continued in her homeland where she viewed the collection of portraits by Johannes Verspronck at the Rijksmuseum in Amsterdam and the Frans Hals Museum in Haarlem, taking particular inspiration from *A Girl Dressed in Blue* (1641), and the 'stillness, beauty and grandeur' of his portrait of *Maria van Strijp* (1652).

'Verspronck painted lace as accurately and detailed as the English Jacobean painters, but added various methods to create greater realism, including shading and blurring,' explains Ploeg. 'I studied the portraits not only as an historian, but also as a painter. I looked for brush strokes, colour choices, glazing and layering techniques.'

By the 1600s, the lacemaking industry provided a living to thousands of women throughout Europe, their creations worn by all but the lowest classes. Made with a needle and single thread (needle lace) or with multiple threads (bobbin lace), the fabric could be unsewn, unlike embroidery, allowing clothing to be altered to easily follow the vicissitudes of fashion. Children as young as five started learning the craft in lace schools, while skilled lacemakers in Flanders, Spain, France and England met the increasing demand from the nobility for linen, silk, gold and silver lace to decorate collars, cuffs and other pieces of clothing.

'A square inch would have taken a lacemaker a whole day of work in the seventeenth century,' says Ploeg. 'Lace machines took over the production in the nineteenth century, but no machine or modern hands can create the refined beauty we find in early lace.'

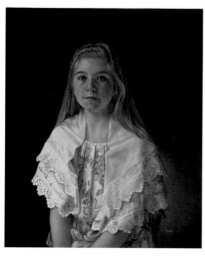

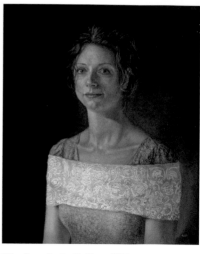

The Lace Maker by Sophie Ploeg, 2013
Oil on linen, 600 x 500mm

A Fine Thread by Sophie Ploeg, 2013
Oil on linen, 600 x 500mm

Ploeg's research also led her to visit modern-day lacemakers in historic lace centres such as Bruges and Honiton, but she was most eager to source authentic early lace in order to paint from life. With lace held in museums not available to use, she hunted down samples in shops across Belgium and England. 'Early lace is nearly extinct save for pieces in museum storage boxes. The fineness of the thread and the design is mind-blowing. It tells stories of art, wealth, fame, fashion and social history, and deserves to be seen and admired before it disintegrates into dust.'

Returning to her Gloucestershire studio, Ploeg crafted those themes into ten oil paintings, using her newly acquired antique lace to make accessories for her sitters. 'A love for fabric has always

been there,' she explains. 'As a child in Holland, my mother taught me how to sew and as a teenager I created my own clothes.'

For the series of paintings *The Four Ages of Woman*, the artist fashioned a collar shape commonly seen in seventeenth-century paintings. 'I used modern women, each in a different stage of their life and painted them as they are,' she says. 'I wanted to combine twenty-first-century women with a piece of lace made and worn by women 400 years ago. It's about connecting the past and the present.'

For the self-portrait, *Pleating Time*, Ploeg created her own ruff, a laborious process involving many metres of fabric gathered tightly together. 'Making a ruff is the most difficult thing,

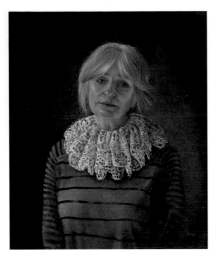

Repeating Patterns by Sophie Ploeg, 2013
Oil on linen, 600 x 500mm

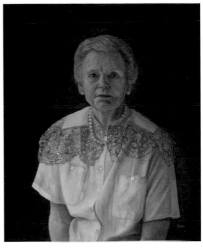

The Pearl Necklace by Sophie Ploeg, 2013
Oil on linen, 600 x 500mm

but I could not resist,' she remarks. 'The pleats function as a timeline, folded and pleated to make jumps in time; now and then, meeting here and there.'

Other paintings are rooted in specific portraits viewed on her travels: *The Long Wait* is a response to Marcus Gheeraerts' *Portrait of an Unknown Pregnant Lady*; *The Handkerchief Girl* alludes to the fashionable handkerchiefs often found in Larkin's portraits; and the whitened comp-lexion of the woman in *She Becomes Her* duplicates the Jacobean vogue for Venetian ceruse and references the work of Robert Peake the Elder, serjeant-painter to King James I.

'In *She Becomes Her*, I wanted to play with the idea of how a modern-day woman might deal with self-

presentation and how she gets represented by others, for instance in the media,' says Ploeg. 'The writing on the picture plane, the newspaper in the background and the sitter's clothes and make-up all suggest she might be hiding her true self.'

Following the completion of the commission, Ploeg plans to continue her trail of discovery. 'I can see new painting paths to explore further ahead,' she says. 'The world today is shaped by the past and so are my paintings. We still struggle with some of the same things that our ancestors struggled with – identity, gender, self-image, fashion, wealth, social class, equality and beauty. Times have changed, but we are still walking the same road.'

Interview by Richard McClure

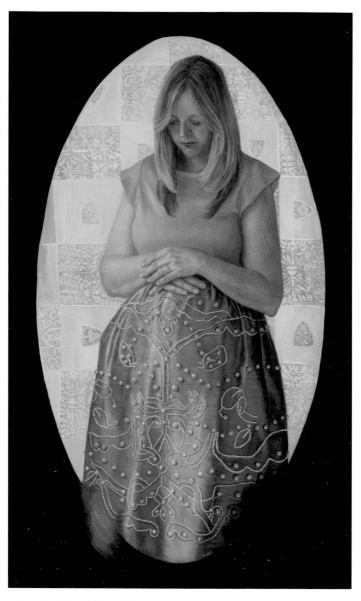

The Long Wait by Sophie Ploeg, 2013
Oil on linen, 1010 x 610mm

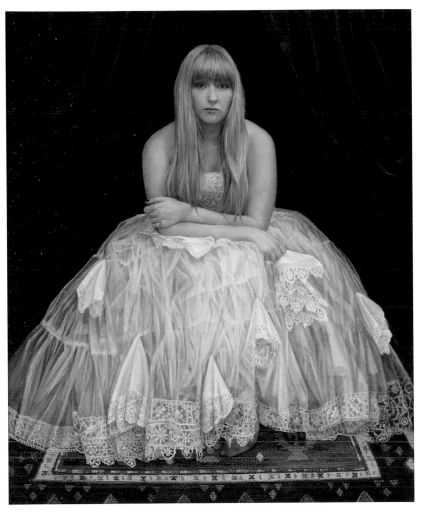

The Handkerchief Girl by Sophie Ploeg, 2013
Oil on linen, 914 x 760mm

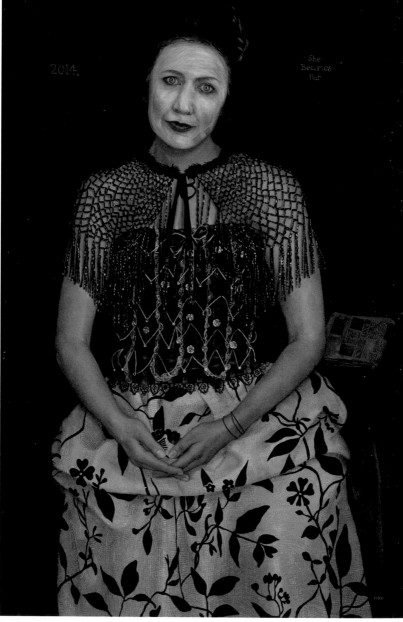

She Becomes Her by Sophie Ploeg, 2013
Oil on linen, 1010 x 660mm

My many congratulations are offered to all the artists in the exhibition, and especially to the prizewinners, Thomas Ganter, Richard Twose and David Jon Kassan, and to Ignacio Estudillo Pérez, the winner of the prize for a younger painter. As always, I am grateful to all the artists across the world who decided to enter the 2014 competition.

I would like to offer many grateful thanks to the judges: Sarah Howgate, Alexander Sturgis, Joanna Trollope, Des Violaris and Jonathan Yeo. They were very attentive in their work, had fascinating and constructive debates, and were concerted in their choices. I should also like to thank the judges of the BP Travel Award: Sarah Howgate, Liz Rideal and Des Violaris. I am very grateful to Julia Donaldson for her delightful essay for the catalogue. She has drawn on her own experience as a subject for a BP Commission undertaken by the previous winner Peter Monkman. I am very grateful to Andrew Roff and Richard McClure for their editorial work, Richard Ardagh Studio for designing the catalogue, and to Clementine Williamson for her excellent overall management of the 2014 BP Portrait Award exhibition. My thanks also go to Pim Baxter, Stacey Bowles, Nick Budden, Rob Carr-Archer, Neil Evans, Tanja Ganjar, Ian Gardner, Justine McLisky, Ruth Müller-Wirth, Nicola Saunders, Jude Simmons, Fiona Smith, Liz Smith, Christopher Tinker, Sarah Tinsley, Ulrike Wachsmann and many other colleagues at the National Portrait Gallery for all their hard work in making the competition and exhibition such a continuing success. My thanks, as in previous years, also go to The White Wall Company for their contribution to the high-quality management of the selection and judging process.

Sandy Nairne

Director, National Portrait Gallery

INDEX